FIELDS OF VISION

The Photographs of Carl Mydans

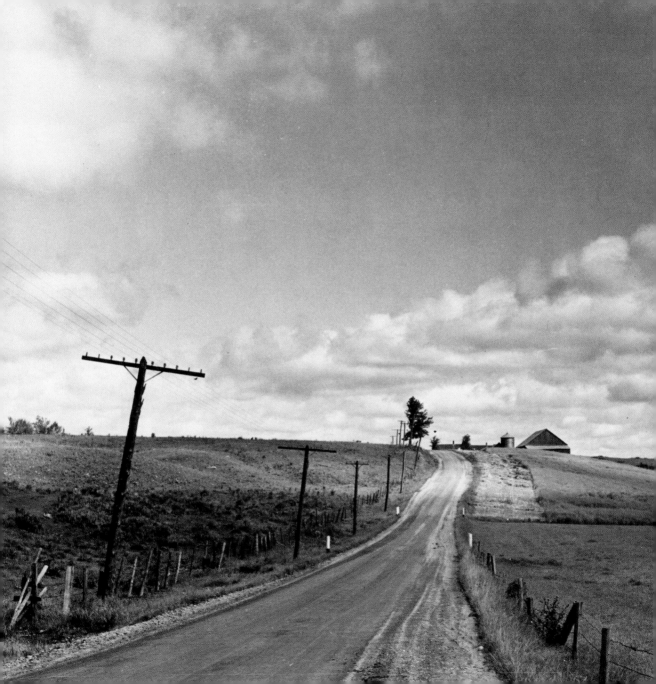

The Photographs of Carl Mydans

Introduction by Annie Proulx

g

THE LIBRARY OF CONGRESS, WASHINGTON, D.C.

Copyright © 2011 The Library of Congress
Introduction © 2011 Annie Proulx
First published in 2011 by GILES
An imprint of D Giles Limited
4 Crescent Stables
139 Upper Richmond Road
London SW15 2TN
UK
www.gilesltd.com

For The Library of Congress:
Director of Publishing: W. Ralph Eubanks
Series Editor and Project Manager: Amy Pastan
Editor: Aimee Hess

For D Giles Limited:
Copyedited and proofread by Melissa Larner
Designed by Miscano, London
Produced by GILES, an imprint of D Giles Limited,
London
Printed and bound in China

**The Library of Congress is grateful for the support of
Furthermore: a program of the J.M. Kaplan Fund**

The Library of Congress, Washington, D.C., in
association with GILES, an imprint of D Giles Limited,
London

Library of Congress Cataloging-in-Publication Data
Mydans, Carl.
 The photographs of Carl Mydans / introduction by
 Annie Proulx.
 p. cm. -- (Fields of vision)
 Photographs from the Farm Security Administration-
 Office of War
Information (FSA-OWI) Collection at the Prints and
 Photograph Division,
Library of Congress.
 Published in association with Giles, London.
 ISBN 978-0-8444-9519-4 (alk. paper)
1. Documentary photography--United States. 2.
 United States--Social life
and customs--1918-1945--Pictorial works. 3. Mydans,
 Carl. 4. Library of
Congress--Photograph collections. I. Proulx, Annie. II.
 Library of
Congress. III. United States. Farm Security
 Administration. IV. United
States. Office of War Information. V. Title.
 TR820.5.M93 2011
 779.092--dc22
 2010051780

Frontispiece: Many Vermont farms lie close to the highways, near Westfield, Vermont, August 1936 (detail).
Opposite: Baby girl of family living on Natchez Trace Project, near Lexington, Tennessee, March 1936 (detail).
Page VI: Carl Mydans standing with his foot on the running board of a Treasury Department Procurement Division Fuel Yard truck, Washington, D.C., c. 1935.
Page VIII: School scene at Cumberland Mountain Farms (Skyline Farms) near Scottsboro, Alabama, June 1936 (detail).

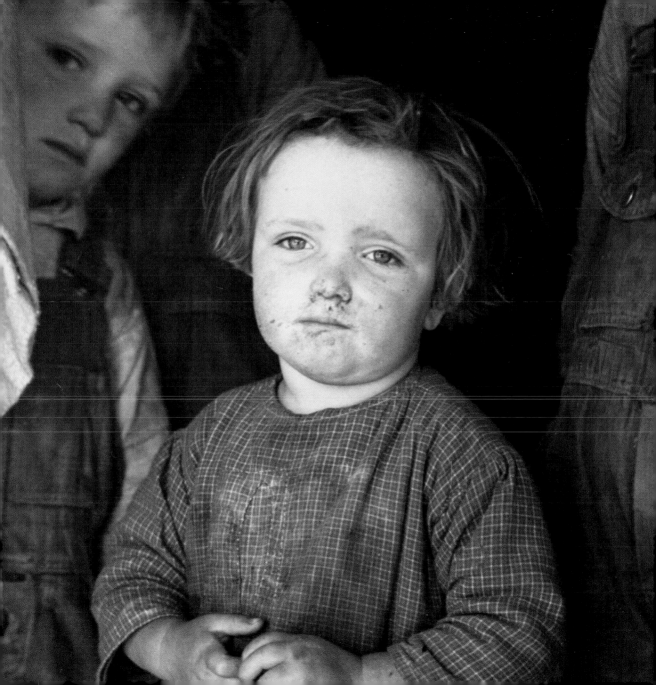

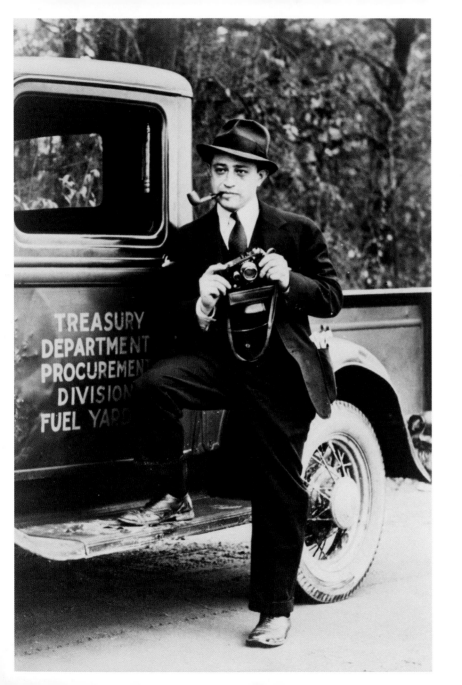

Fields of Vision
Preface

The Farm Security Administration–Office of War Information (FSA–OWI) Collection at the Library of Congress offers a detailed portrait of life in the United States from the years of the Great Depression through World War II. Documenting every region of the country, all classes of people, and focusing on the rhythms of daily life, from plowing fields to saying prayers, the approximately 171,000 black-and-white and 1,600 color images allow viewers to connect personally with the 1930s and 1940s. That's what great photographs do. They capture people and moments in time with an intimacy and grace that gently touches the imagination. Whether it's a fading snapshot or an artfully composed sepia print, a photograph can engage the mind and senses much like a lively conversation. You may study the clothes worn by the subject, examine a tangled facial expression, or ponder a landscape or building that no longer exists, except as captured by the photographer's lens long ago. Soon, even if you weren't at a barbeque in Pie Town, New Mexico, in the 1940s or picking cotton in rural Mississippi in the 1930s, you begin to sense what life there was like. You become part of the experience.

This is the goal of *Fields of Vision*. Each volume presents a portfolio of little-known images by America's greatest photographers—including Russell Lee, Ben Shahn, Marion Post Wolcott, John Vachon, Jack Delano, Esther Bubley, Gordon Parks, and Arthur Rothstein—allowing readers actively to engage with the extraordinary photographic work produced for the FSA–OWI. Many of the photographers featured did not see themselves as artists, yet their pictures have a visual and emotional impact that will touch you as deeply as any great masterwork. These iconic images of Depression-era America are very much a part of the canon of twentieth-century American photography. Writer James Agee declared that documentary work should capture "the cruel radiance of what is." He believed that inside each image there resided "a personal test, the hurdle of you, the would-be narrator, trying to ascertain what you truly believe is." The writers of the texts for *Fields of Vision* contemplate the "cruel radiance" that lives in each of the images. They also delve into the reasons why the men and women who worked for the FSA–OWI were able to apply their skills so effectively, creating bodies of work that seem to gain significance with time.

The fifty images presented here are just a brief road map to the riches of the Farm Security Administration Collection. If you like what you see, you can find more to contemplate at our website, www.loc.gov. The FSA–OWI collection is a public archive. These photographs were created by government photographers for a federally funded program. Yet they outlived the agency they served and exceeded its mission. Evoking the heartbreak of a family who lost its home in the Dust Bowl or the humiliation of segregation in the South, they transcend the ordinary—and that is true art.

W. Ralph Eubanks
Director of Publishing
Library of Congress

Carl Mydans

By Annie Proulx

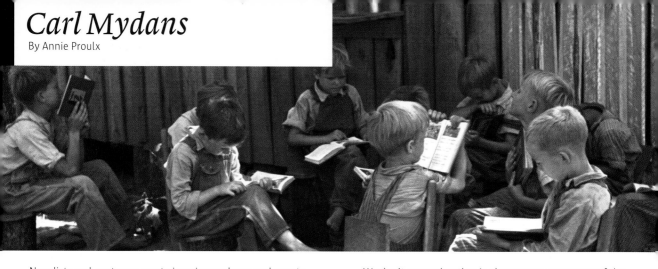

Novelists and poets can create imaginary places and events with nothing more than paper, pen, and their minds—the Grand Duchy of Grimbart, Xanadu, Utopia—places where no photographer has gone. Photography takes the real world as its subject matter. Discounting the ambitious manipulators and postmodern appropriators of photographs, we still think of the medium as a record of verisimilitude. In the popular mind the photograph records reality, and this presumed documentary function gives it authority as a reliable historical record. The Farm Security Administration (FSA) photographs taken from 1935 to 1943, however tweaked, however guided by political goals and government propaganda, however colored by personal ambition, self-expression, or fine art goals, were and are generally accepted as showing something of the true lives of some United States citizens during the Great Depression years. But when they first appeared they aroused vitriolic denunciation in conservative circles for presenting Americans in less than idealized circumstances. The enemies were powerful and many, right-wing shouters who saw the photographs as a god-awful waste of money, infuriated people who felt the shocking pictures threw mud at the country. There are still those, even after 75 years, who would like to see the files destroyed, and others who wish each administration had continued with similar projects.

We don't remember that in those years 25 percent of the country's population made a living from agriculture, many of them subsistence farms that were not part of the money economy. We don't remember that the U.S. wheat crop in 1931 broke all records, glutting the market and driving down prices, nor the 30-day strike of the Iowa Farmers' Union militants, who stopped farm trucks heading to market and broke their headlights (telling the farmers to go home) in protest at the meager sums paid for agricultural produce. We don't remember that 38 percent of American families had incomes of less than a thousand dollars a year (equivalent to $15,000 today), nor that H. L. Hunt's Texas oil properties were bringing him about a million dollars a week. And the Liberty League, whose wealthy members included the du Ponts, Alfred Sloan of General Motors, and J. Howard Pew of Sun Oil, fiercely opposed New Deal economics, but who remembers that? And we've forgotten, if we ever knew, the scalding work of the subsistence and tenant farmers whose lives were little better than those of medieval peasants.

What we do remember of the 1930s are those FSA photographs, images of dust storms surging over the horizon, skanky Okies and Arkies, dirt-smeared children and down-and-out country people burned into our consciousnesses, embedded in our history, tightly woven into our folklore and firing a sense of

ourselves as a people who have known poverty and deprivation. Carl Mydans, already an experienced photographer who had sold pictures to *Time*, became one of the handful of government photographers who traveled the country recording how we lived in the 1930s, contributing to the collective portrait of an unequal society. Mydans' time with the FSA was brief; after 16 months he resigned and moved on to the new magazine *Life,* and a long and celebrated career as a war photographer. He identified himself as a photojournalist and his interest in the massive global events of the time became his life.

Carl Mydans (1907–2004) was born in Boston, the grandson of a Russian immigrant bookbinder from a village near Odessa. His father was a professional musician. When the family moved to Medford, Massachusetts, Mydans worked weekends for local boatyard owners. One, he recalls in his autobiography, *Carl Mydans, Photojournalist*, was an important influence in his life. "Bob Cheney…taught me how to use my hands, and he would often stop me and say, stand back and look at it, and if you think you've done a good job, that's it. If you don't think you've done a good job, then go back and redo it or do it a little better next time. Those are words that I have never forgotten, and whenever I looked at a picture or looked at the possibility of a picture that I am going to make I often hear his words….He didn't say meet *his* expectations, he said meet *my* expectations. It was one of the most profound things that ever was said to me." The pattern was set in these years for Mydans' almost obsessive lifetime habit of printing the day's work before he went to bed, noting the details of times, places, names in his omnipresent notebooks.

Mydans graduated from the School of Journalism at Boston University in 1930. At university he began using a big Graflex camera to take photographs for the institution's publicity office. He moved on to New York and worked as a reporter for *American Banker*. After he took a course in photography at the Brooklyn Institute of Arts and Sciences to deepen the stories he wrote, he bought a small, second-hand 35 millimeter Contax. "When I began to use my 35 mm camera, I was never separated from it. I wore it often under my jacket, on my shoulder like a weapon in a holster. I always had the feeling from the time I got up in

the morning until I went back to bed at night that something was going to happen in front of me, and when it did, I wanted my camera to be there." At that time newsmen regarded this miniature camera as "that goddamned little toy." He brought the goddamned little toy to the Resettlement Administration (later incorporated into the FSA) and for most of the photographers it became the project's instrument of choice. His own photograph here at age 28 (p. vi), looking much older than his years, shows him with the Contax, his jacket pocket sagging with the notebooks and pencils he always carried.

In America under the New Deal something was happening not unlike the seventeenth-century enclosure movement in England, a shift from famine-plagued tiny subsistence farms to large holdings and for-profit agriculture. Gradually the old English subsistence farmers lost their little holdings and became hired laborers on the new enclosures, not without a great deal of hardship and suffering. With Roosevelt's Agricultural Adjustment Act (AAA) price supports were tied to crop reductions. The AAA paid growers to plant fewer crops, but forgot about their tenant farmers. Landowners got the message that they could take the government money, buy agricultural machinery, especially tractors, and get rid of tenants, horses, and mules. The phrase "tractored out" described these suddenly homeless tenants who joined the waves of people wandering across the country looking for work. The Resettlement Administration (established April, 1935), with Rexford Tugwell, the dashing Columbia University economist, as its director, was meant to help dispossessed tenants with loans and a dozen other aids. It later morphed into the Farm Security Administration. The program lacked popular support. Very few people had the faintest clue about the problems of low-visibility tenant farmers. Tugwell's idea had been to form an FSA "Historical Section" that would be charged with showing Americans the desperate plight of poor rural tenant farmers. He hired Roy Stryker, who had been his graduate assistant at Columbia University, to run the outfit.

Stryker seems to have been born for the FSA job. He grew up on his ranting, Populist father's Colorado farm and

had a firsthand understanding of the problems of hard-scrabble agriculture. At Columbia he had been, like Tugwell, an inspired teacher reaching far beyond the economics textbooks for real-life lessons. One student, Calvin Kytle, later described some of his teaching methods, saying Stryker would bring "pictures to the class—mostly illustrations from the newspapers and magazines of the day. He would tack them to the wall and point. 'You want to know about economics?' he would ask. 'Economics is not money. Economics is people. *This* is economics.' "

At Columbia Stryker was responsible for gathering photographs to illustrate Tugwell's proposed but never completed book, *American Economic Life*, and discovered that most magazine and newspaper photographs depicted rosy, idealized lives. He developed an eye for powerful, gritty photographs, on his way to becoming an authority on documentary photography.

Mydans came to Stryker in a circuitous way. He and Walker Evans joined the group as numbers five and six. He received film, a $35 weekly salary, an expense allowance of $5 a day plus three cents a mile for travel. This was high on the hog, for the Historical Section's budget was pitiful. Although John Vachon took photographs, he was a "messenger," with an annual salary of $1,080. Most of the photographers got detailed shooting scripts, for Stryker had an agenda and knew what he needed from his middle-class hirelings who had no first-hand experience of rural poverty. Mydans told photographer Hank O'Neal who interviewed him for *Vision Shared*: "I remember the first time I was going off on a story for Stryker's section. My assignment was to go to the south and 'do cotton.' I put my cameras together, drew my film, got my itinerary and came in to see Roy and tell him I was on my way. He greeted me, wished me luck, and then struck with a sudden thought said: 'By the way, what do you know about cotton?' I said, 'Not very much.'"

Stryker immediately postponed the date of Mydans' departure and for the rest of the day and into the night told him all about cotton.

Mydans later stated that Stryker was the second important influence on his life. In a 1984 interview with Philip Kunhardt, Jr., he said, "Roy Stryker had a very similar characteristic [to that of Bob Cheney] about *is this good or bad?* He would sometimes pick up a picture that I made and look at it. He was an intense, visual historian. And he would say I like that picture but that lamppost there in the foreground, I don't like that. Don't tell me it was there. I don't want to know anything about a picture that isn't right. I want you to make a picture that is *right*.' " Mydans maintained a high level desire to create pictures that were *right* through the rest of his life and it made him one of the most noted photographers of the twentieth century.

Andy Grundberg wrote in Mydans' obituary in the *New York Times* that he "specialized in getting one picture that told the story by itself." It was and is a popular myth that photographs tell stories. Certainly in the 1930s and '40s there was a near-universal belief in photographs as storytellers. Indeed, *Life* magazine was founded on the premise that photographs told stories. The closest they came to storytelling was the photo essay, a series of linked photographs that presented some change or development in a situation. The FSA photographs did not really tell stories beyond the very brief statement that some people in this country were god-awful poor and living dead-end lives, and that the government believed it could alleviate some of this injustice. In *Looking at Photographs* John Szarkowski remarked that "Notwithstanding frequent claims to the contrary, photography has never been very successful at telling stories….Photographers gradually came to recognize this, and the best of them began to subvert the narrative idea, and to make instead pictures that memorialized the quality of a particular moment."

For example, the photograph titled "The auto trailer camp, Dennis Port, Massachusetts, August 1936" (42) fails to tell a story. All over the country people were moving along, separated from what had once been home. Because we know that fact we assume that the trailer and tent shelter parked at the auto trailer camp near Dennis Port, Massachusetts, shows this dispossessed wandering. We interpret the photograph as an on-the-road scene. Yet there are clues that it may be a depiction

of a comfortable family enjoying a holiday outing. The trailer is smart and probably was rather expensive. The woman knitting in a wicker chair radiates placidity. The staring stances of the two girls, wearing jackets on a cool day, provide the only tension. The campground photographs of holiday travelers that most of the FSA photographers took were often mistakenly seen as homeless persons on the road.

In many of these photographs we can almost see Stryker leaning over Mydans' shoulder. Stryker wanted to show real-life poverty and he wanted to show how government help could alleviate much misery. So one can see how the photographs alternate between condemnation and celebration. House interiors, especially kitchens, were good subjects.

In two graphic and depressing pictures we see awful kitchens. Although both have cold running water there is no electricity. In one (16) we see a family group, three unkempt children in a tight knot staring at the camera, their round-shouldered mother facing them, a folded paper in her hands. A man—the father?—stands to the right, his hand on a chair back, as if he has just come through the door behind him, its white china knob and the gleam of his leather belt pulling our eyes away from the interior as though marking the exit for a quick escape. The room reeks of poverty. A woodstove, door ajar, must serve for heat and cooking as well as storage of black, dented pots. Behind it is a wall shelf holding sad irons, a nearly full ash bucket, and an empty wood basket. The design on the dingy oilcloth table cover is worn to faint blotches. Under the single window is a large chest and balanced on it the hated laundry tub. On the miniscule counter beside the sink is a box of EASY TASK soap chips (an ironic label under the circumstances) and a half-empty milk bottle.

The second kitchen (28) is even more dreadful. Mydans has interrupted the ironing. We see seven sad irons heating on the stove. The kitchen table serves as the ironing board, heavy cloths spread over it. Other chores seem in progress; dish washing, something being mixed—perhaps biscuits—in a bowl while the irons heat. The chair appears as a double image, giving the photograph an eerie aspect deepened by the lumpy pregnant cat

lying in front of the grim stove as though dead. All is dark with old dirt that no amount of scrubbing can remove.

One of the most powerful of these indoor photographs ("Interior of Ozarks cabin housing six people, Missouri, May 1936"; 15) shows a young white woman, already stooped and shapeless, seated on a cot, breast-feeding her infant. At her left her daughter, perhaps six, wriggles and half-smiles goofily. Their sockless feet are thrust into worn-out shoes. The window frame is roughly constructed. The walls have been freshly papered with pages from the *Chicago Herald-Examiner*, a paper with underworld connections that folded in 1939. A toy tractor stands on the windowsill. The woman is poor, too poor for privacy, and she stares at Mydans and his camera and at us with suppressed rage, her face expressing recognition and hatred of her own vulnerability. The issue of intrusion and the photographer's prying camera is rarely discussed, but years later Mydans remarked that as a war photographer he used his camera as a shield, and it is likely that it served as at least a psychological safeguard during his months with the FSA. "I think it is fair to say that all war photographers hide behind their cameras. I hid behind mine for years and years and years."

In great contrast to these dismal kitchens with their newspaper walls, greasy cast-iron sinks and cumbersome woodstoves is a triumphant photograph of a New Jersey homesteader in government quarters (27). The kitchen is airy and spotless; it has a large white porcelain sink, a gas range, and a 30-gallon water heater. Dishes and cooking pots are stored in modern cabinets. The lucky housewife's white high heels echo the whiteness of the appliances. We can just see the edge of a table in the lower right corner. It is covered, not with worn oilcloth, but a snowy white tablecloth.

Almost half of these photographs show children; the marks of poverty seem to besmirch their innocence. One of the strongest pictures is of an unkempt, ragged boy in northern Vermont, the son of a woodcutter (7). Perhaps ten- or eleven- years- old, he stands dressed in rags, hands in pockets, his face somber and unsmiling. Behind him scribbled grass and a decaying building, the background focus blurred as if the boy was already distancing

himself from his childhood in this place and time. Mydans has caught something of his anger and resentment.

The portraits of children are intensely moving. We can glimpse the dark future of a nine-year-old girl, with wild tousled hair and feed-sack dress, breasts already enlarging (25). The dirt-smeared boy at her side and the ear of another on the right seem to indicate that she takes care of her younger siblings. On the 2x4s that serve as structural supports and shelves we see a rag, a can, and an empty pint whisky bottle. A teenage black boy stands beside a bin mounted on sled runners instead of wheels (41). His starved horse in ragged harness is dragging the load of tobacco to market. The horse's days are numbered, the boy has little future. The ensemble speaks of no exit.

In contrast there are several pictures that show white, well-dressed children, emphasizing the gulf between secure families and the poor. In one (36) we see four white children, two boys and two girls, nicely dressed, bows in the girls' hair, clean and well-nourished; they stand in front of a substantial stone building in Washington, D. C., and hold child-sized newspapers. One girl offers the other a copy. In the paper held by the boy on the left we can make out part of the word AMBITION.

The Vermont State Fair was a big occasion for rural families, and many camped out near the fairgrounds, pulling seats out of the automobile, stringing up clothes (laundry never took a holiday), cooking and eating al fresco. Here (46) a mother with four young children fixes the hair of a little girl. A long row of cars, tents, and temporary shelters recedes into the distance. They may not be wealthy but they are getting along.

"Parade at the fair, Albany, Vermont, September 1936" (13) presents people in costumes, a float, a smiling lady in white pumps and two little boys about four years old dressed in white trousers, homemade tailcoats, and top hats. It is a breezy day and the elm branches blur. The boys carry walking sticks and the nearest boy doffs his hat to the photographer. Behind them a float lavishly decorated with crepe paper carries a replica of a New England house. An incongruous touch is the frilly Chinese cabbage reposing on the side of the float. The scene speaks of happiness and a good time.

And of course there are pictures showing poor children who have been rescued from privation by government programs enjoying better lives. On a planned government Homestead project in Decatur, Indiana, six smiling girls and boys fill the road as they walk home from school, hand in hand (4). The shortened shadows show that it is noontime. They are carrying report cards, an indication that this is a half-day and likely the last day of school. Behind them are the neat, roomy government-built houses and mowed lawns. Another winner gives us the Penderlea Homestead in North Carolina, a subsistence housing project offering rental-lease arrangements. A handsome young man milks a Jersey cow tied to a neat corral fence against a background of cornstalks, but his smiling attention is on the beloved toddler leaning against him (14). It is a picture of well-being and independence, thanks to a helping-hand government. Another successful resettlement couple is Marion Hills and his wife photographed hoeing in their garden, both clean and neat with a decent house in the background (32). They cultivate young plants, Mrs. Hill wearing her high heels. Although pets rarely appear in these photos the Hills are accompanied by his dog and her cat.

Housing contrasts were another Stryker interest. Owning one's house was part of the American dream, but the realities varied enormously. Mydans recorded urban tenements, New England farms, the shacks of black and white people, trailers, tents, and homeless walkers. Cincinnati's ramshackle frame houses were perched close beside each other on an embankment above the multiple railroad tracks (22). None of the shabby houses had indoor plumbing, and down the steep slope behind each stood a tilted and noisome outhouse that undoubtedly wobbled when a train went by. In Milwaukee rows of brick houses were jammed close to what Mydans called "junk," though it looks more like a tidy, fenced auto salvage yard (11). No doubt once the United States got into World War II all of these fenders, bodies, and radiators were a scrap metal bonanza for the owner.

A dilapidated cedar smokehouse was a sad historical reminder of the red cedar forest that once grew in one part

of Tennessee (49). The forest was cut down in the nineteenth century and subsistence farmers tried to raise crops on the poor soil among the stumps. In 1934 the Resettlement Administration started reforestation in the area—the Wilson Cedar Forest Project. The Works Progress Administration (WPA), manned by the local farmers who had tried vainly to make a living in the stump land, built roads, put in power lines, built cabins. The area became one of Tennessee's first state parks, today known as Lebanon Cedar Forest.

An abandoned and melancholy Vermont hill farm littered with broken machinery shows lilac shrubs still persisting and a distant view of the mountains (45). We don't know where the owners have gone. Less disturbing is the Lewis Hinter family (48). Hinter, wearing a ruined hat at a jaunty angle, stands in front of his shack on Lady's Island, South Carolina. Beside him are his wife, four children, and an older woman, likely his mother or mother-in-law. The house isn't much, everyone is ragged, but there is a feeling of this family as a sturdy, cohesive unit—all they need is a little help.

In an alley doorway of a brick row house in Washington, D.C., a mother dressed in her Sunday dress and hat and gleaming white silk stockings smiles and frowns at the same time (12). She leans over a baby missing one shoe. The missing shoe, like the Chinese cabbage in the Vermont State Fair parade, is the tiny incongruous detail that seemed to appeal to Mydans. Four other children sit on the steps or stand in the doorway. There is a sense of hasty dressing for this photograph. Did Mydans wait while the mother stuffed the children into their garments? The picture somehow conveys the feeling of an important occasion.

It is hard to know how the photograph of Mr. and Mrs. Phillips (29) fit into Stryker's good and bad categories. We see a Missouri couple in their eighties standing on the doorstep of their cabin built of square-hewn logs and chinked with mud. The chinking is falling out, but the cabin stands square and firm. It looks like a good house. The couple appears healthy and fit despite their age. Mrs. Phillips wears a sunbonnet of nineteenth-century style. The impression is of two people who are managing a decent living, subsistence though it may be. However, to Stryker and

people of the 1930s, the picture may have conveyed the message of old-fashioned, worn-out, sub-standard housing.

Work versus No-Work was another Stryker theme. Outside the Prairie City, Missouri, grocery store four men sit and squat (5). One reads the paper intently and they all just—wait. Similarly in Batesville, Arkansas, a row of "typical" farmers sit in the shade and while away the time talking, spitting, whittling (41). We understand there are no jobs. We understand that rural America is uninteresting, that there is nothing to do there.

Men would take any kind of work, and the New Brunswick, New Jersey, photograph of a narrow snow-clogged street (21) meant a day's work and a little money. We see the men shoveling, and to the right, more available shovels. A huge storage tank at the end of the street seems to advance on them—progress or lack of zoning regulations?

Mydans photographed a pith-helmeted carpenter hammering planks (23), a Pennsylvania miner in a warm jacket with a shearling collar leading a mule (33), two North Carolina men plowing land in March, preparing it for the spring planting (34). In Maryland three sexily shirtless, muscular young men with the Civilian Conservation Corps swing pickaxes and shovel dirt in the August heat (39). And a South Carolina rehabilitation couple proudly shows off one day's harvesting work—seven brimming bushels of ripe tomatoes (30). The boy with them seems to slightly disengage himself from the scene.

Most of these photographs demonstrate Mydans' skill at getting inside what he saw. That was the identifying marker of his FSA and later work, catching the quality of a particular moment. It is more accurate to call his photographs "situational" rather than documentary. What made him an outstanding photographer, sensitive and conscientious, was his smart ability to grasp a large event and in his bones know how to capture its essence, distilling a small piece of the whole into a telling image. In part the impact is achieved by leaving out extraneous detail and concentrating on a central node in the tangle of moving history. When we look at his works we do not think of the photographer, but of the event and the times.

1

"Damned if we'll work for what they pay folks hereabouts." Cotton workers on the road, carrying all they possess in the world, Crittenden County, Arkansas, May 1936.

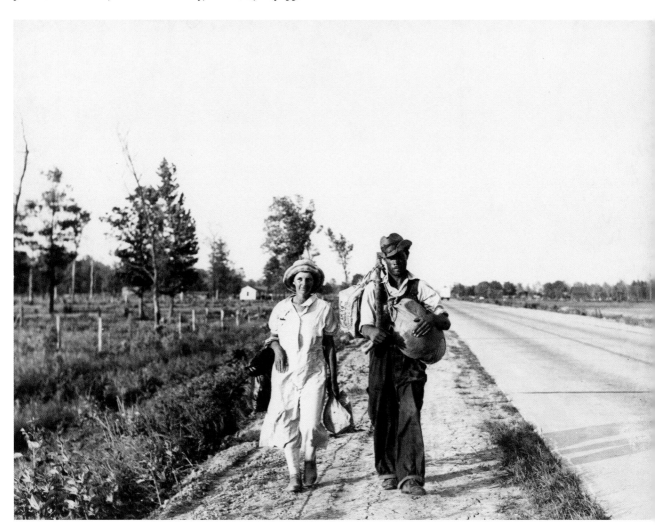

2

Men leaving work at Greenbelt, Maryland, July 1936.

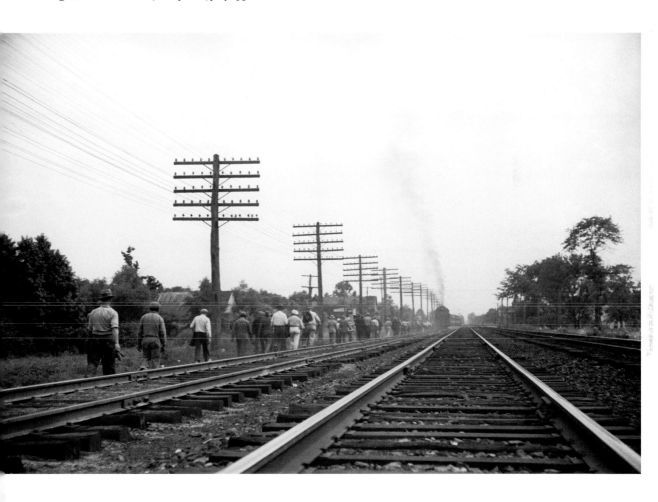

3

Alley near L Street, N.W., Blake School in background, Washington, D.C., November 1935.

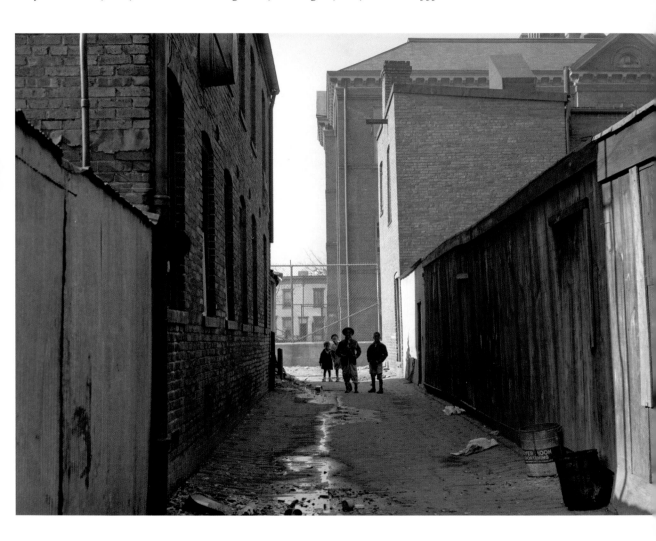

Homestead children coming home from school, Decatur Homesteads, Indiana, May 1936.

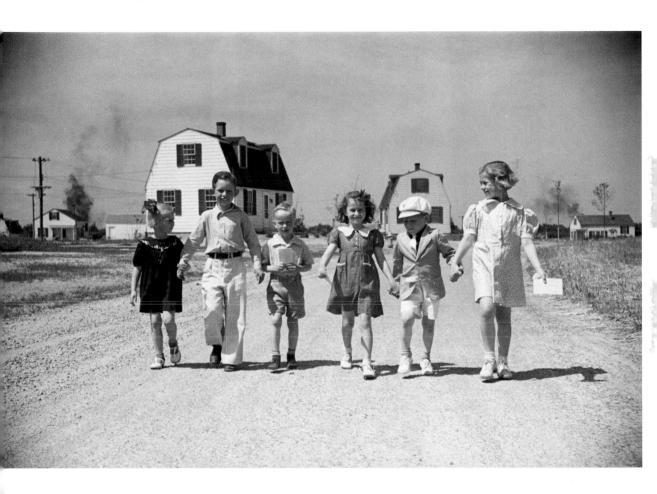

5

Typical farmer group of Prairie City, Missouri, in Mississippi County, March 1936.

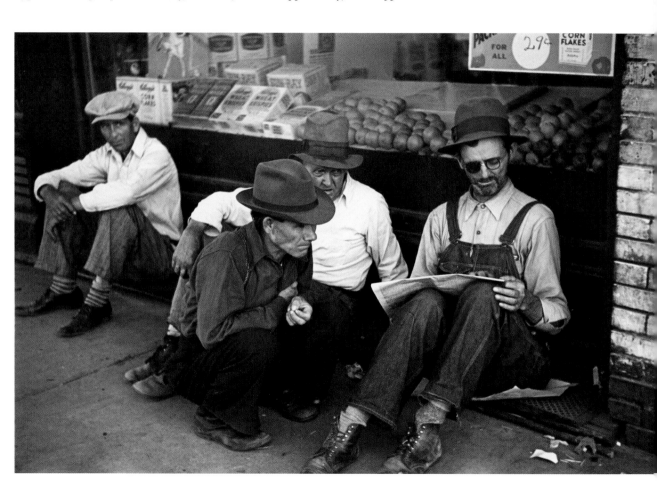

6

School scene at Cumberland Mountain Farms (Skyline Farms) near Scottsboro, Alabama, June 1936.

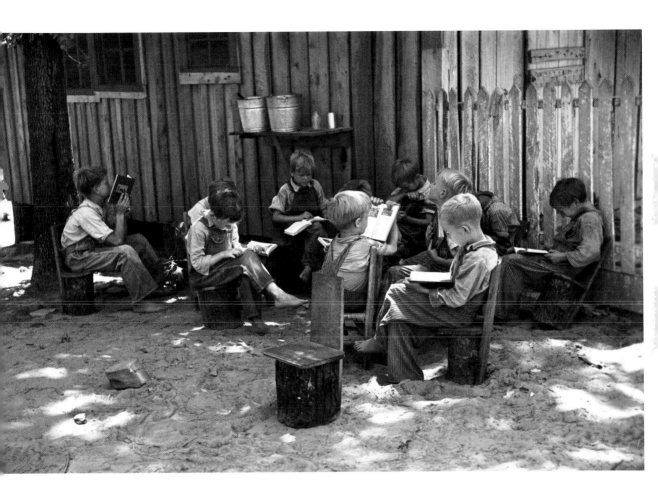

Son of a woodcutter, Eden Mills, Vermont, August 1936.

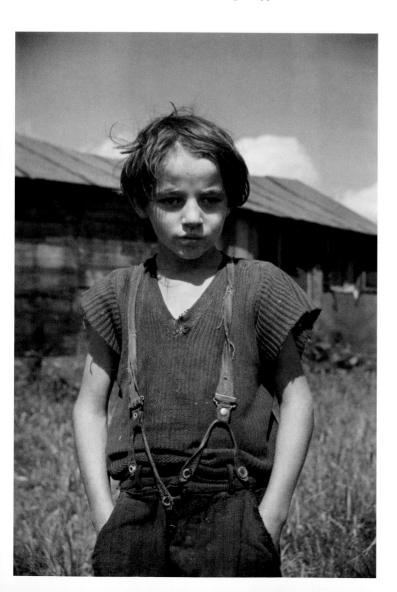

Baby girl of family living on Natchez Trace Project, near Lexington, Tennessee, March 1936.

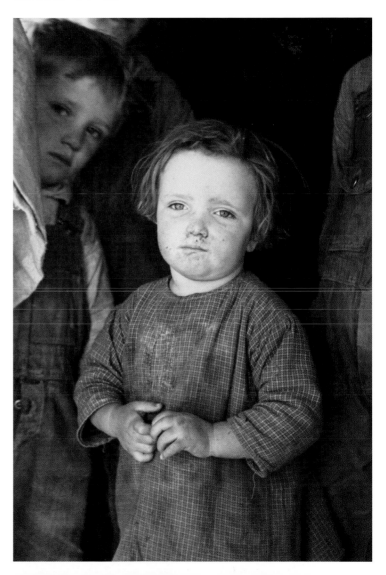

Church at crossroads on sea level highway, south of Charleston, South Carolina, June-July 1936.

Fellows and Son casket manufacturers, employer of 200 to 350 people, Amoskeag, New Hampshire, September 1936.

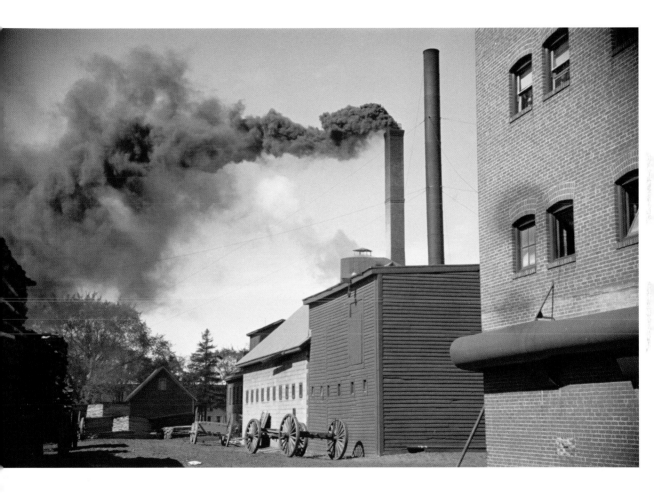

Junk, with living quarters close by, Milwaukee, Wisconsin, April 1936.

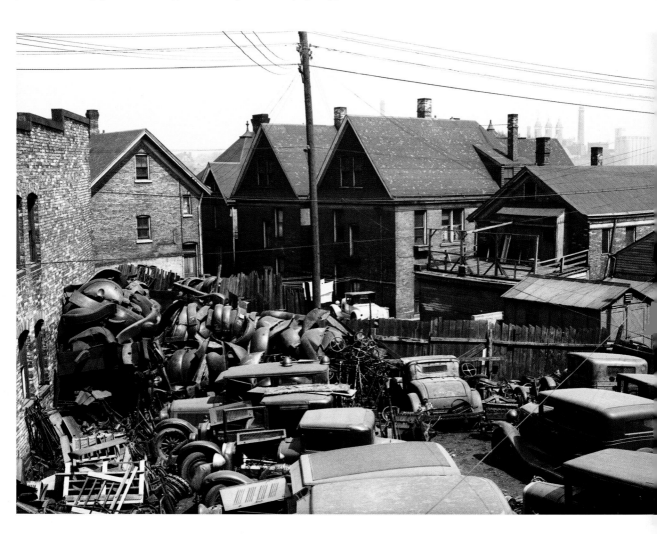

12

Youngsters in doorway of alley dwelling, Washington, D.C., November 1935.

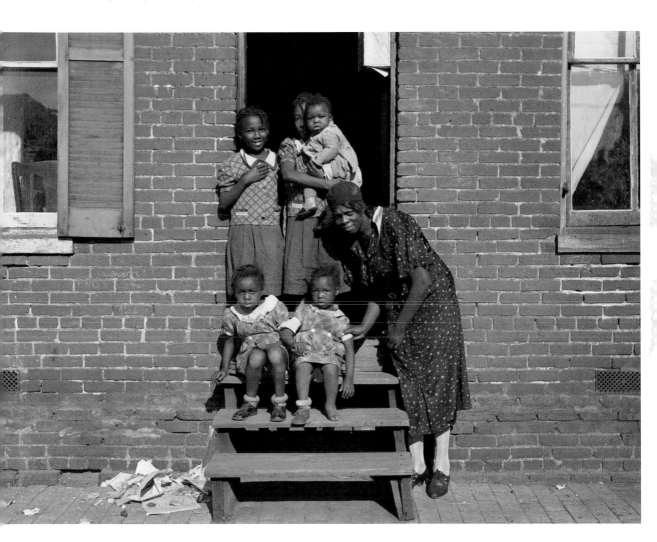

13

Parade at the fair, Albany, Vermont, September 1936.

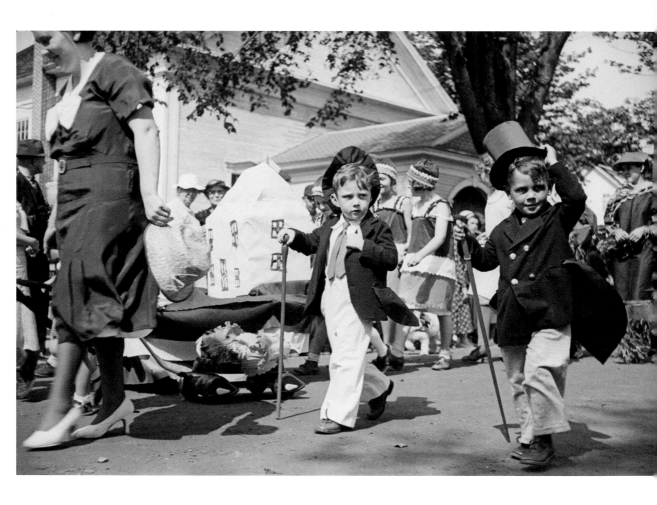

Penderlea Homesteads, North Carolina, August 1936.

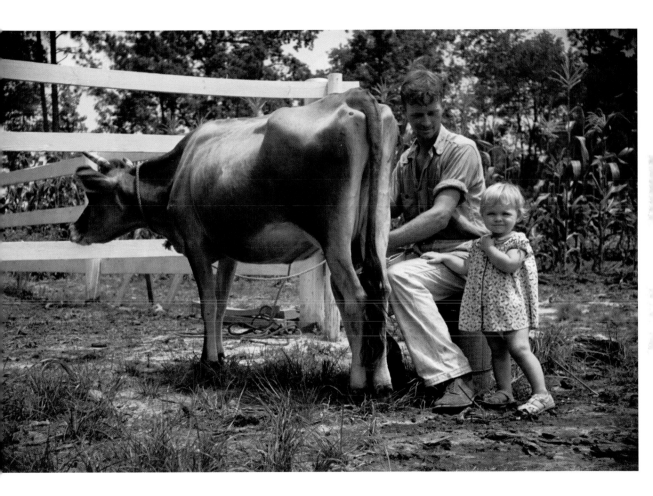

Interior of Ozarks cabin housing six people, Missouri, May 1936.

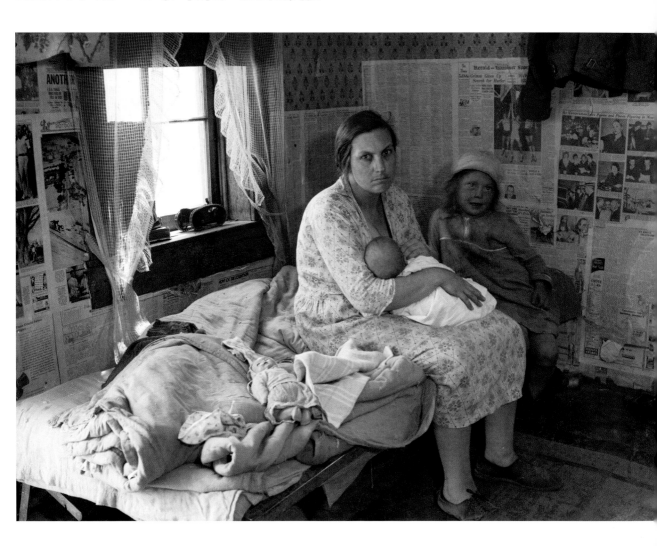

Tenement kitchen, Hamilton County, Ohio, December 1935.

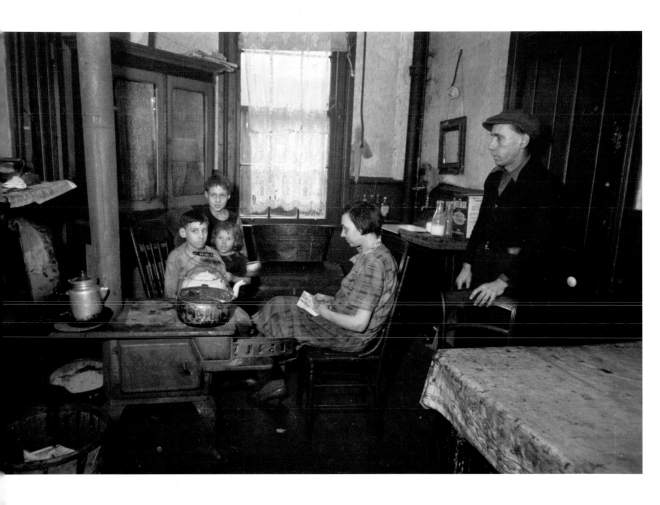

Taxi driver, Washington, D.C., c. 1935.

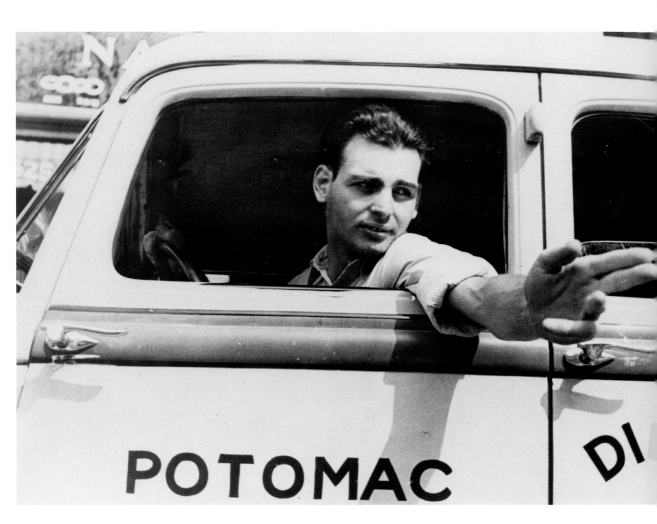

18

Street car motorman, Washington, D.C., c. 1936.

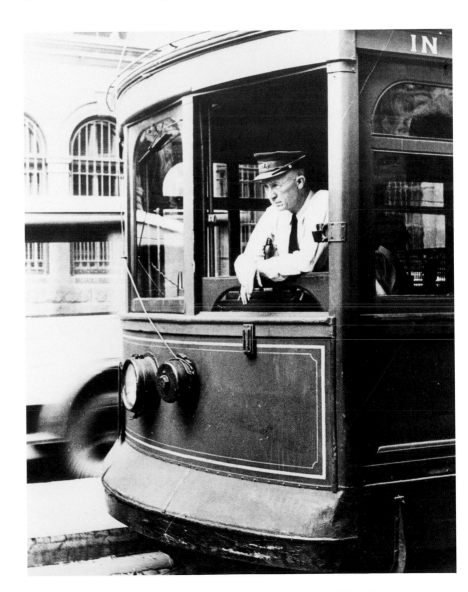

19

Roosevelt banner, Hardwick, Vermont, September 1936.

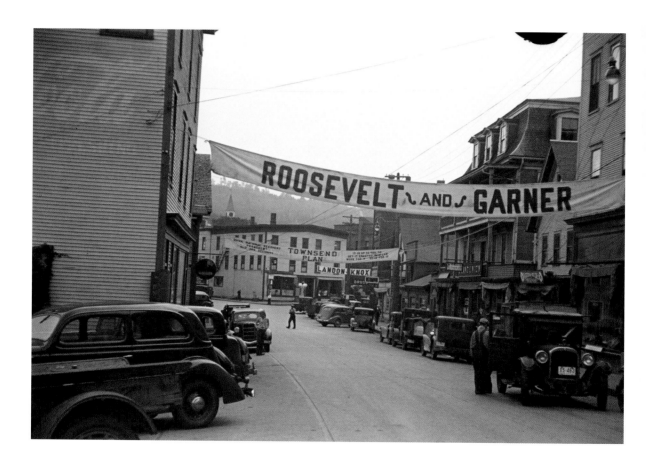

Typical view of store and cotton trader in small Arkansas town, Marianna, Arkansas, June 1936.

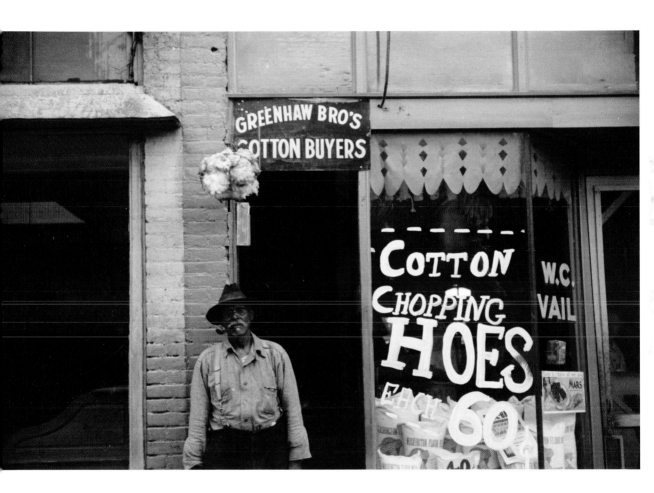

Narrow street in New Brunswick, New Jersey, February 1936.

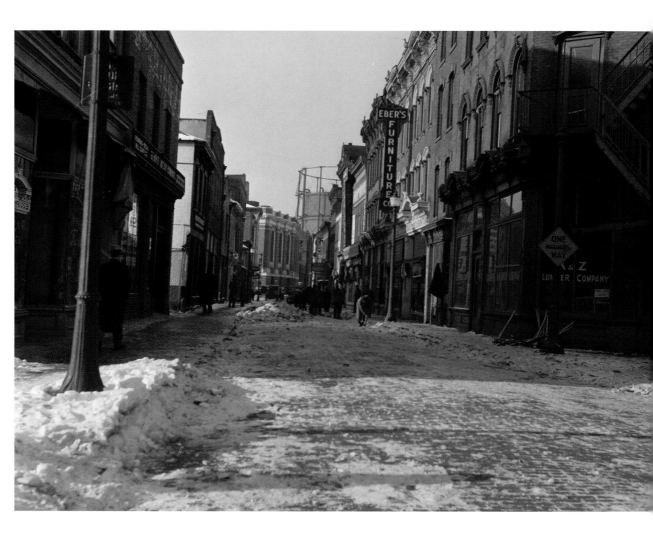

Cincinnati, Ohio, December 1935.

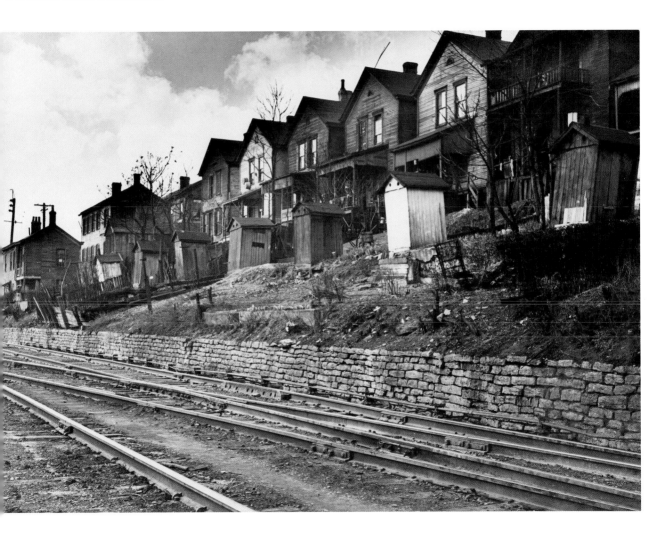

23

Carpenter at Greenbelt, Maryland, August 1936.

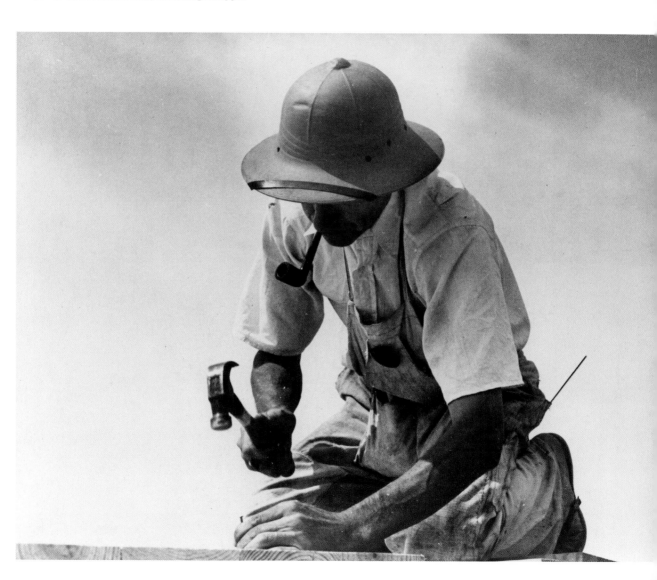

Tin-type photographer at Morrisville, Vermont, fair, August 1936.

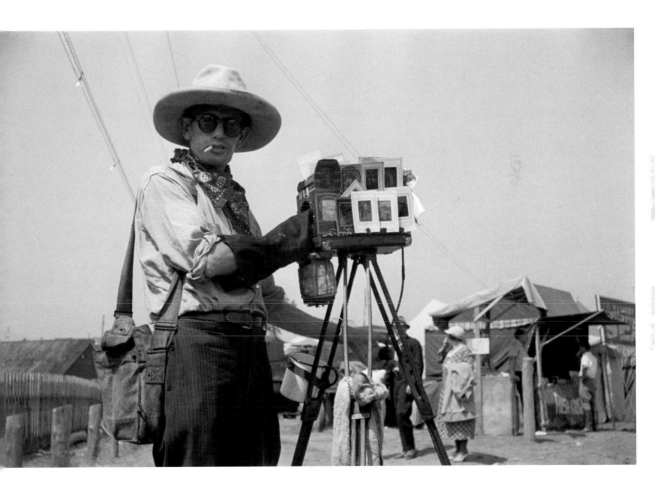

Girl of family of nine living in a one-room hut built over the chassis of an abandoned Ford truck on U.S. Route 70 between Camden and Bruceton, Tennessee, March 1936.

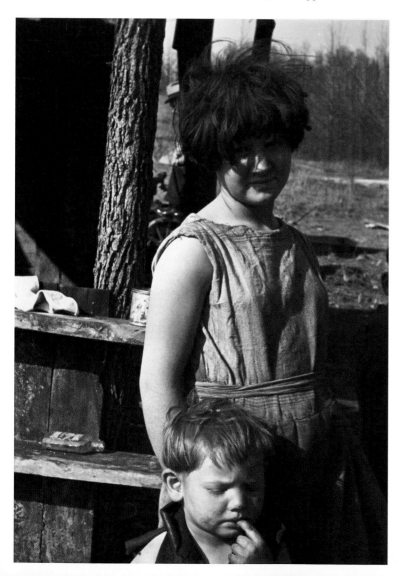

Poor white children living in the Georgetown neighborhood of Washington, D.C., November 1935.

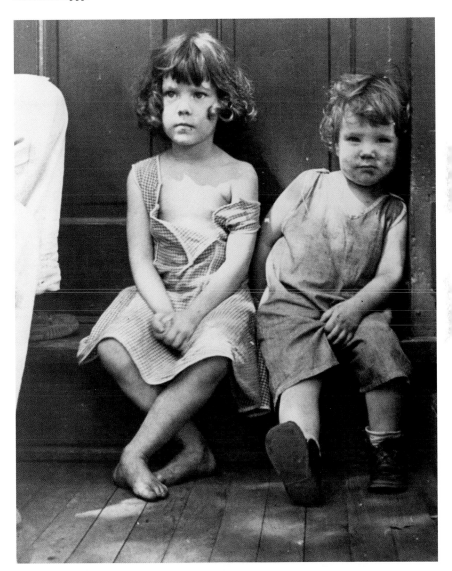

27

Homesteader in the kitchen of her new home, Hightstown, New Jersey, August 1936.

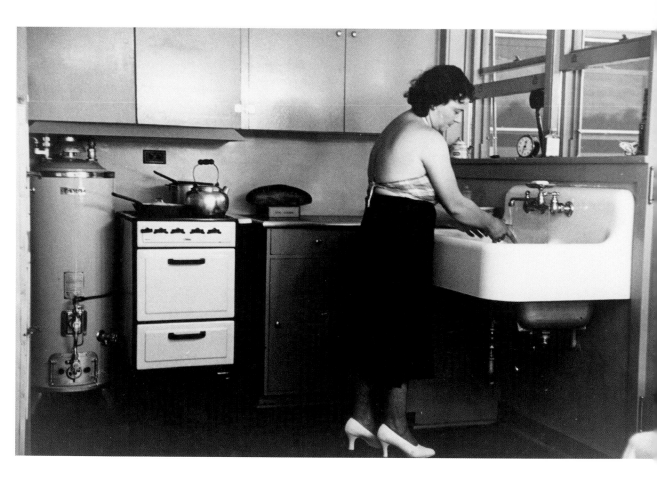

Negro's kitchen near Union Station, Washington, D.C., November 1935.

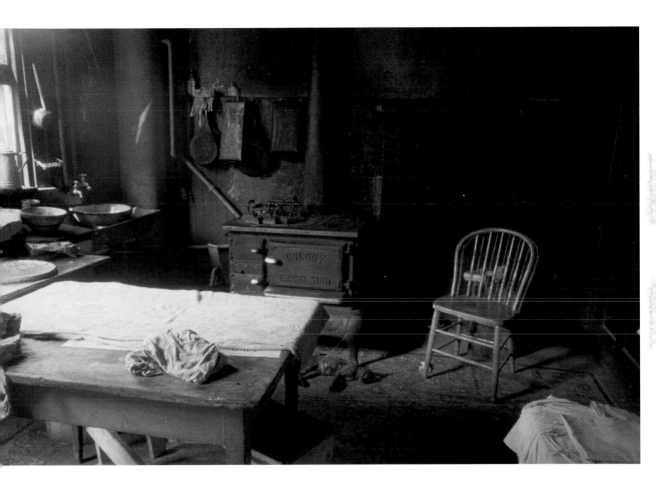

Nick Phillips, eighty-one years old, with wife in front of house, Ashland, Missouri, May 1936.

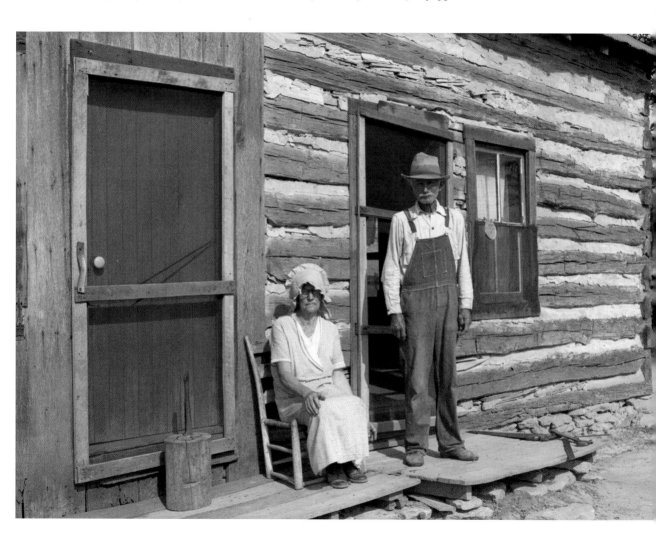

Rehabilitation client and his wife with one day's tomato pick off the coast of Beaufort, South Carolina, June-July 1936.

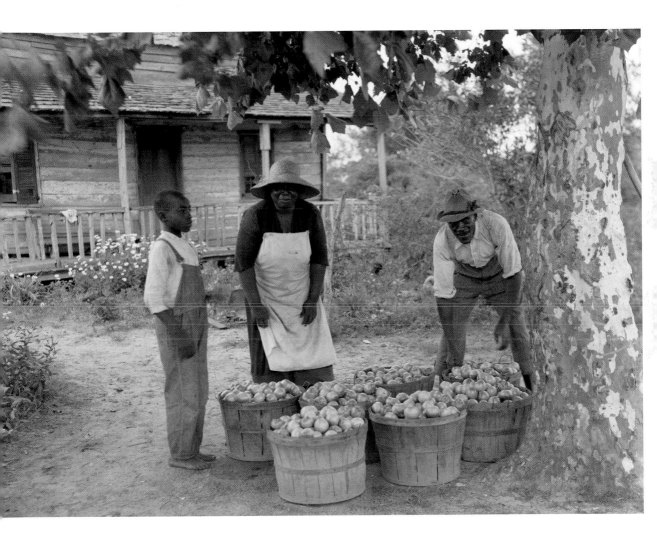

Rehabilitation Administration supervisor Keller pointing to calves born from cows purchased with a rehabilitation loan to Mr. Wilks, Callaway County, Missouri, May 1936.

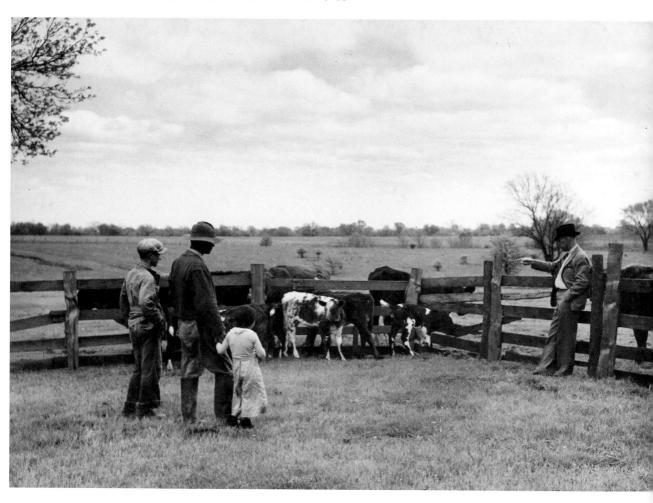

Off to a new start, Marion Hills and his wife, rehabilitation clients, in the garden of their farm, Center County, Iowa, May 1936.

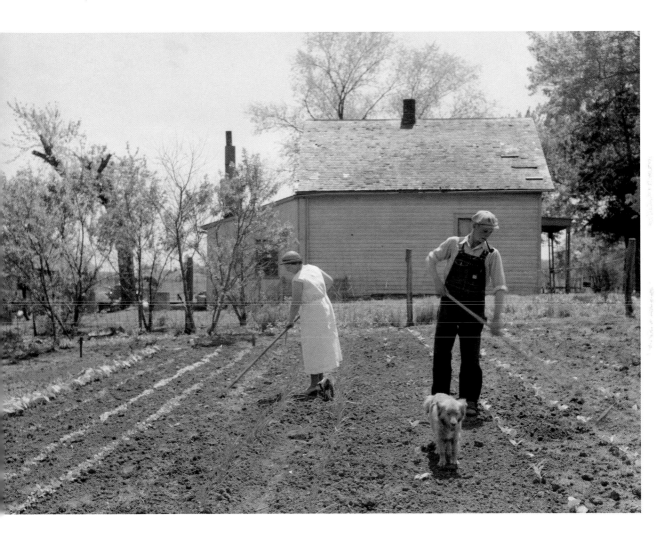

33

Miner and mule at American Radiator Mine, Mount Pleasant, Westmoreland County, Pennsylvania, February 1936.

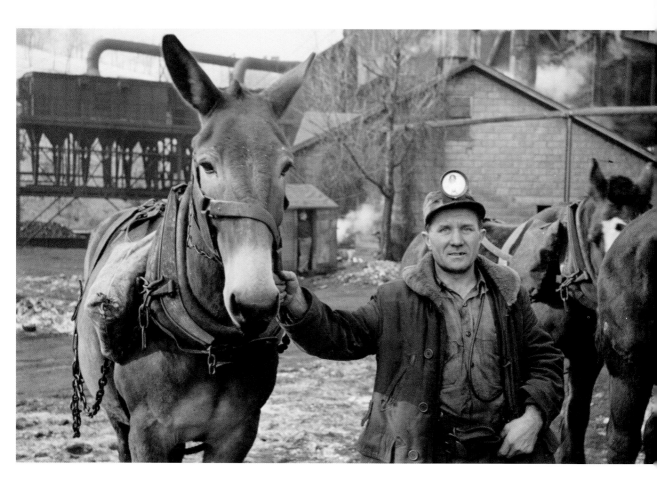

Getting the ground ready for spring planting, North Carolina, March 1936.

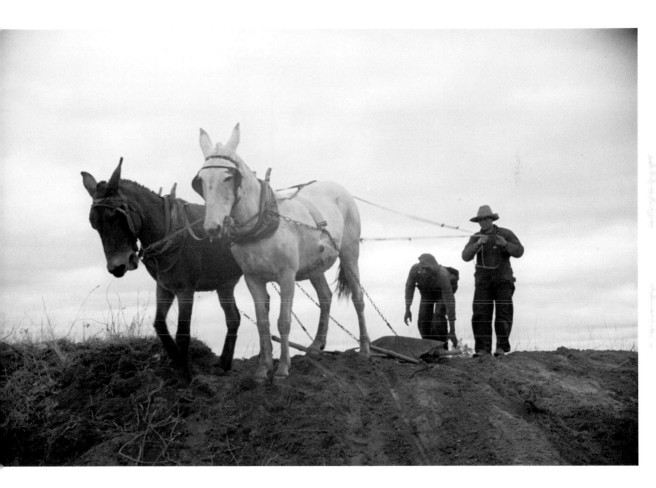

Children of a Negro sharecropper at pump, near West Memphis, Arkansas, June 1936.

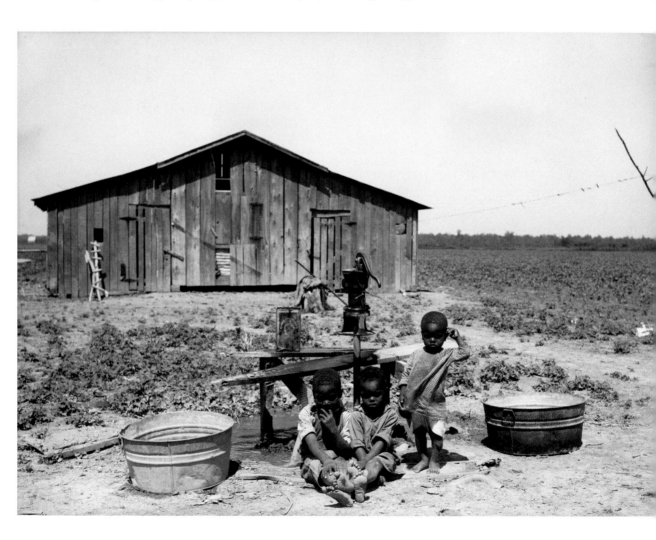

Healthy white children, Washington, D.C., November 1935.

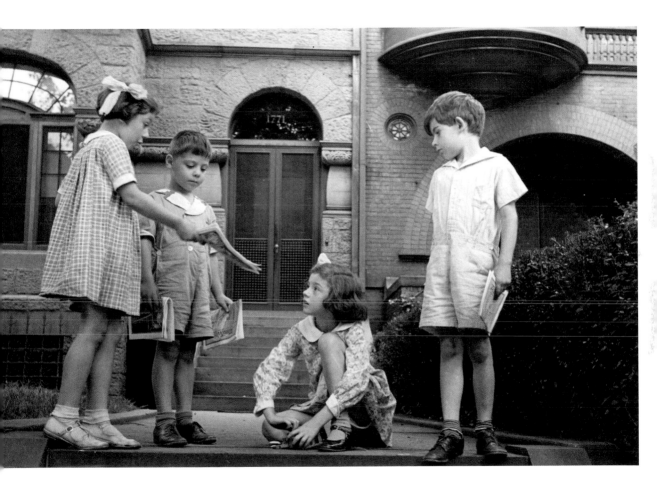

Many Vermont farms lie close to the highways, near Westfield, Vermont, August 1936.

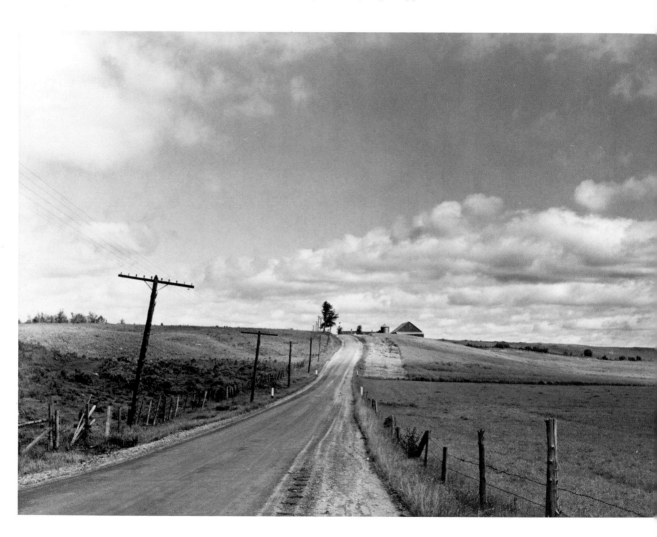

Housing alongside Chicago and Milwaukee Railroad, Milwaukee, Wisconsin, April 1936.

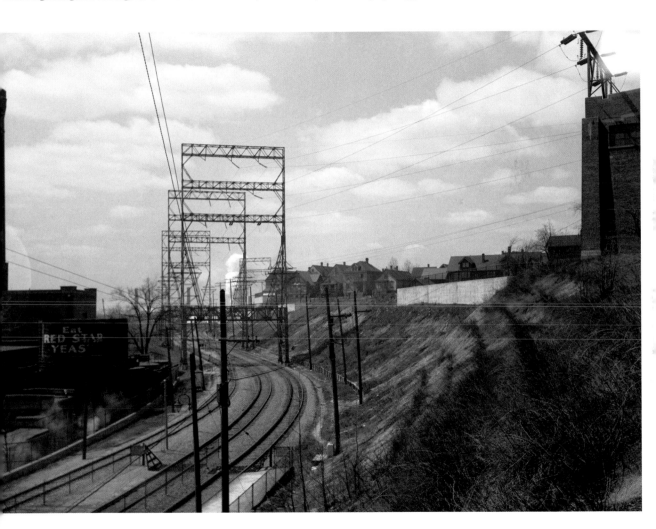

CCC (Civilian Conservation Corps) boys at work, Prince George's County, Maryland, August 1935.

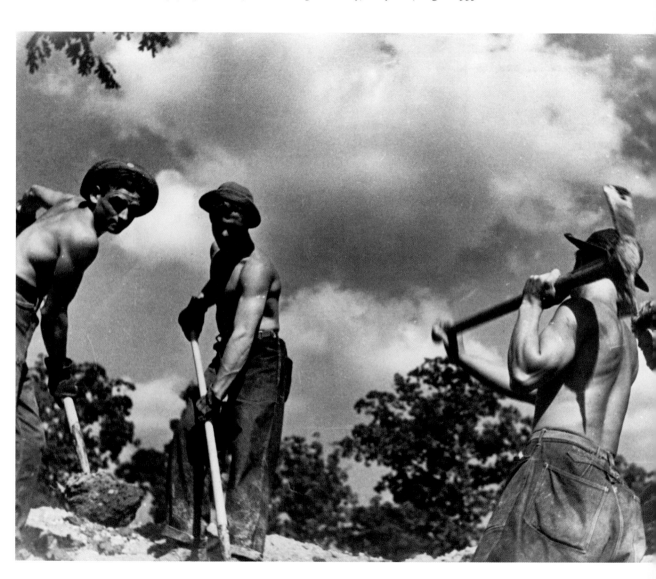

Children at play, Washington, D.C., November 1935.

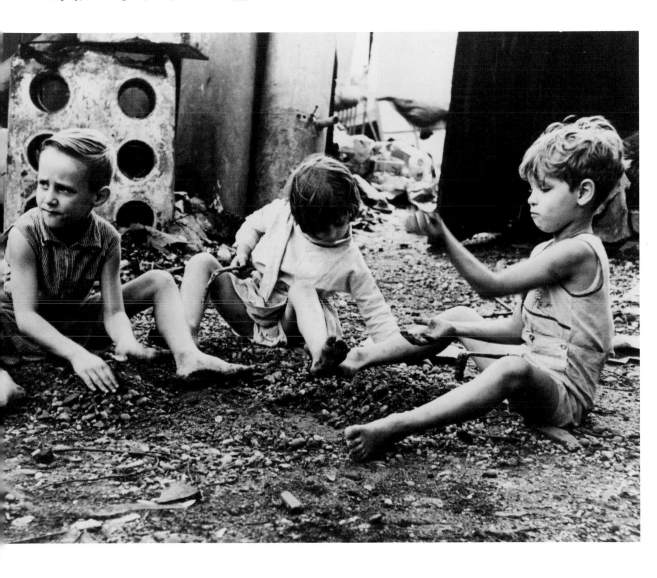

41

Tobacco going to market near Stockton, Georgia, June 1936.

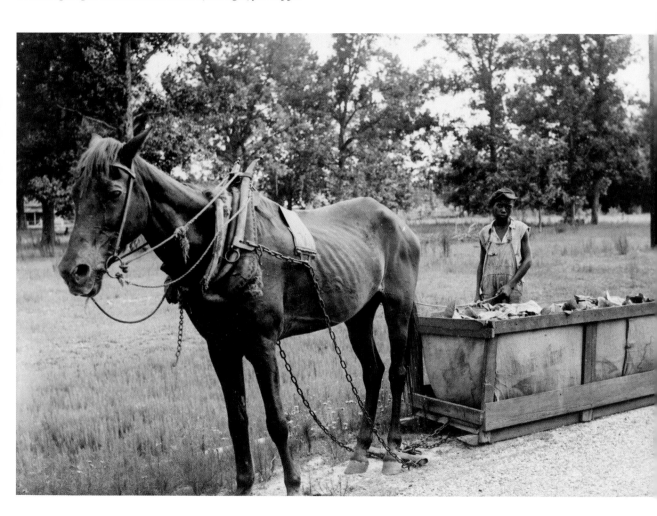

The auto trailer camp, Dennis Port, Massachusetts, August 1936.

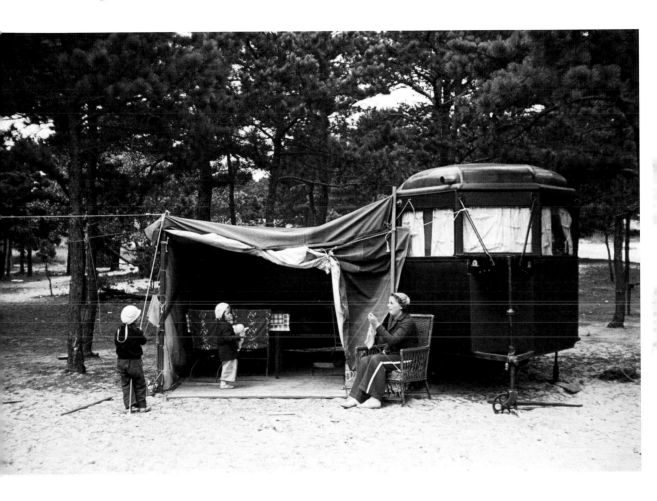

Steam shovel operator working on homestead at Hightstown, New Jersey, November, 1935.

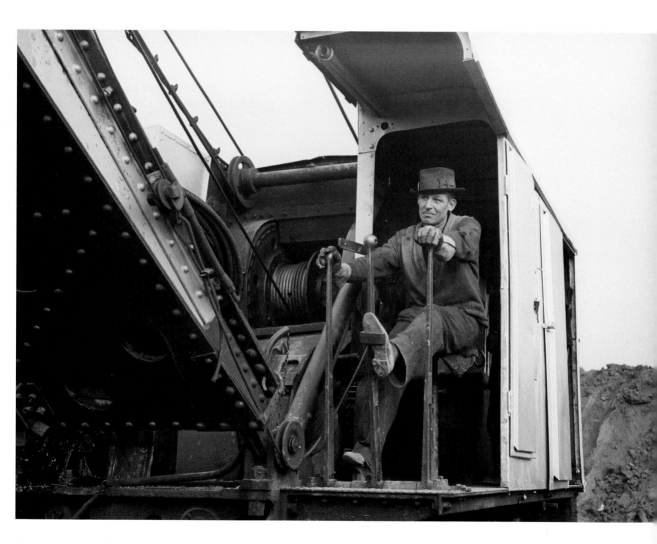

Potato laboratory, Prince George's County, Maryland, August 1935.

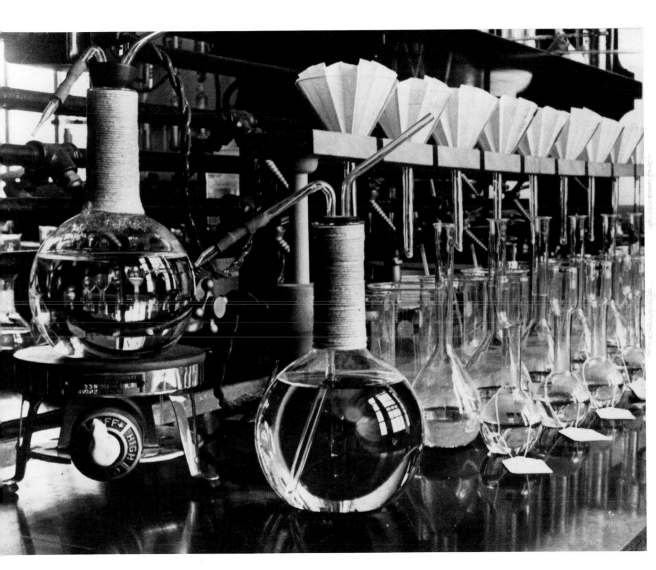

Old abandoned farmhouse near Newport, Vermont, August 1936.

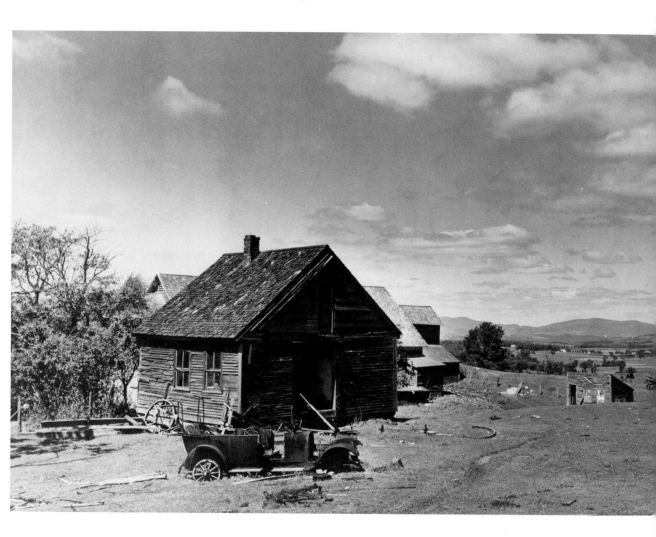

Farm families come prepared to live at the fair, Morrisville, Vermont, August 1936.

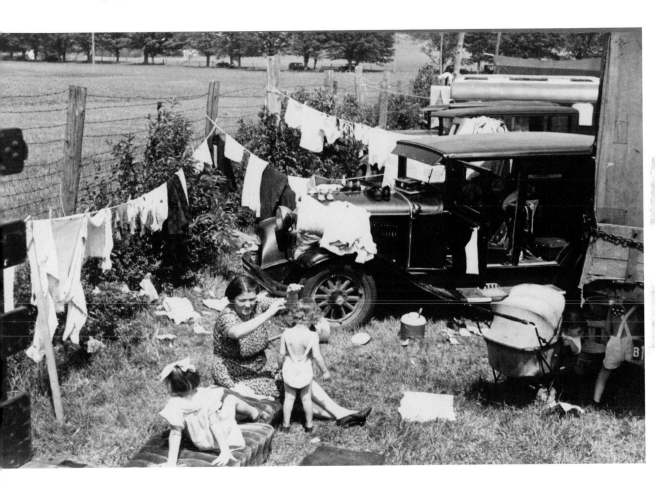

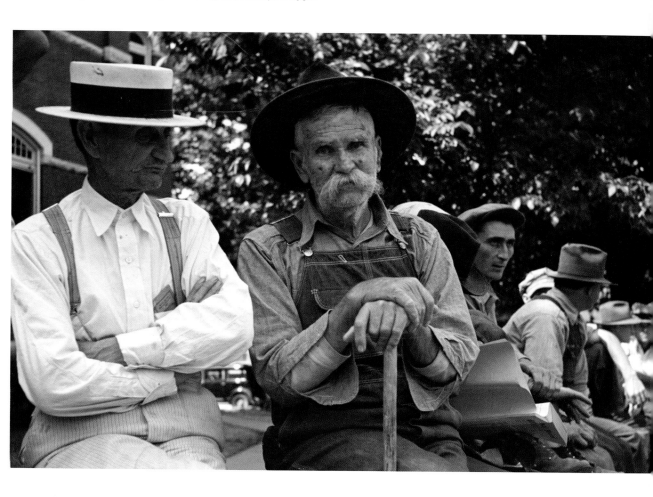

47

Loafers' wall by the courthouse, Batesville, Arkansas, June 1936.

Lewis Hinter, a Negro client, with his family on Lady's Island off Beaufort, South Carolina, June-July 1936.

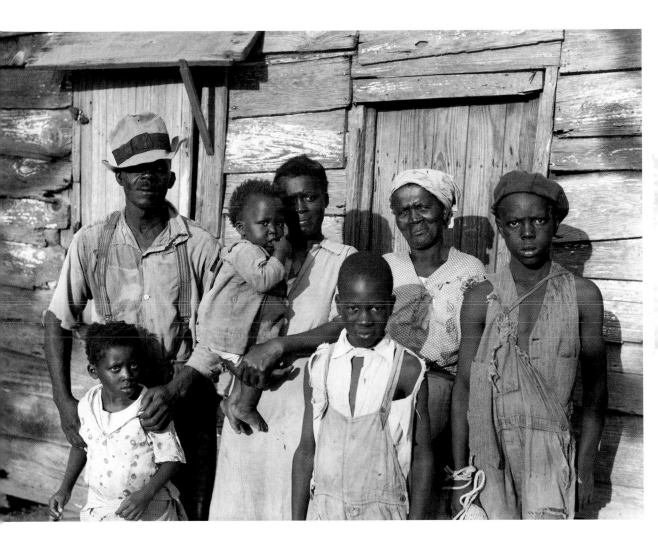

49

Smokehouse of cedar at Wilson Cedar Forest project, near Lebanon, Tennessee, March 1935.

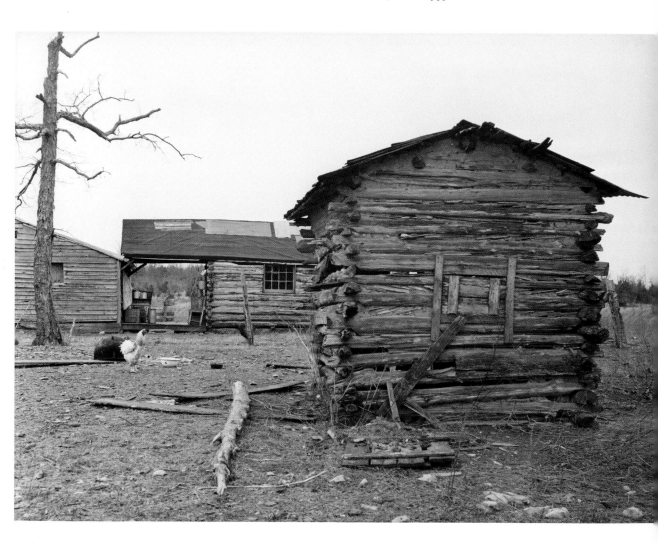

Monument in Jefferson Davis Park marking the spot where Jefferson Davis was captured by Union Soldiers on May 10, 1865; monument erected by United Daughters of the Confederacy chapter, Ocilla, Georgia, June 1936.

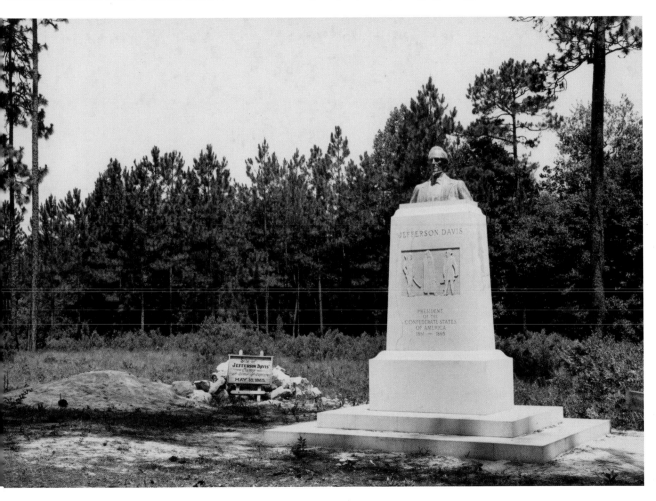

Images

The images in the Farm Security Administration–Office of War Information (FSA–OWI) Photograph Collection form an extensive pictorial record of American life between 1935 and 1944. In total, the collection consists of about 171,000 black-and-white film negatives and transparencies, 1,610 color transparencies, and around 107,000 black-and-white photographic prints, most of which were made from the negatives and transparencies.

All images are from the Library of Congress, Prints and Photographs Division. The reproduction numbers noted below correspond to the page on which the image appears. Each number bears the prefix LC-DIG-fsa (e.g., LC-DIG-fsa-8a16183). The entire number should be cited when ordering reproductions. To order, direct your request to: The Library of Congress, Duplication Services, Washington, D.C. 20450-4570, tel. 202-707-5640. Alternatively, digitized image files may be downloaded from the Prints and Photographs website at http://www.loc.gov/pictures.